Tattoo Artists

Jeanne Nagle

ROSEN
PUBLISHING®

New York

For Laura. Hope this inspires you.

Published in 2009 by The Rosen Publishing Group, Inc.
29 East 21st Street, New York, NY 10010

Library of Congress Cataloging-in-Publication Data

Nagle, Jeanne M.
Tattoo artists / Jeanne Nagle.
 p. cm.—(Tattooing)
Includes bibliographical references.
ISBN-13: 978-1-4042-1790-4 (library binding)
1. Tattoo artists. 2. Tattooing. I. Title.
GT2345.N34 2009
391.6'5023—dc22

2007048652

Manufactured in Malaysia

On the cover: A tattoo artist creates an elaborate tattoo.

Contents

INTRODUCTION

They have been respected in certain cultures and looked down upon or feared in others. Throughout the centuries, they have worked at the request of kings, nobility, and celebrities, as well as thieves and other scoundrels. Today, their popularity is on a meteoric rise and yet, for the most part, they remain anonymous. Their art—seen every day in studios and galleries, and on living canvases, namely people's bodies, around the globe—is forever. They are tattoo artists, or tattooists.

An interesting mix of artist, chemist, mechanical whiz, safety professional, and businessperson, the tattoo artist is a unique, hardworking individual. Yet for a long time, tattooists have gotten strange reactions when they have told others about their job. There are a couple of reasons for this.

First, the artistic aspect of the job is foreign to a lot of people. While everyone can appreciate art—looking at it, owning it, maybe even creating it at an amateur level—they don't always understand what it means to be an artist. Like others who create art for a living, tattooists do not keep regular schedules like an office worker or somebody who has to punch a time card. Also, their income is frequently unsteady, varying from week to week, month in and month out.

Then there is tattooing's history. In the past, body art could mostly be found on slaves, criminals, sailors, circus performers, or gang members. In other words, tattoos, and tattoo artists, had been mostly associated with people who weren't part of mainstream society.

That's not the case anymore. Tattooing is gaining in popularity and is better understood than ever before. People from all walks of life are discovering the joy and fun to be found in body art, and they have tattoo artists to thank for that.

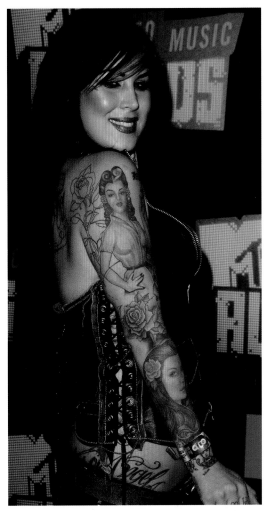

Tattooing is so popular that tattoo artists are becoming celebrities. Kat Von D, the star of television's *LA Ink*, is nearly as famous as her star clients.

What Makes Someone a Tattoo Artist

Tattooing has had a long history of attracting some pretty rough customers. In olden days, pirates and robbers could be identified and distinguished from civilized folks by their tattoos. Hundreds of years later, motorcycle riders, prison inmates, and members of street gangs made a point of getting tattooed as a sign of unity, to show their dedication and loyalty to each other. Since tattooing is painful, getting body art also has served as permanent proof of how strong someone is.

Because they deal with and frequently hang out with these types of clients, tattoo artists have earned a reputation for being just as tough. In the movies and on television, they are often shown as large, scary men dressed in black and wearing leather, artwork covering much of their skin. While there are men (and these days, women) who fit this description, at least as far as their appearance, tattoo artists aren't necessarily frightening, uncivilized individuals. It would be more accurate to describe them as nonconformists, which

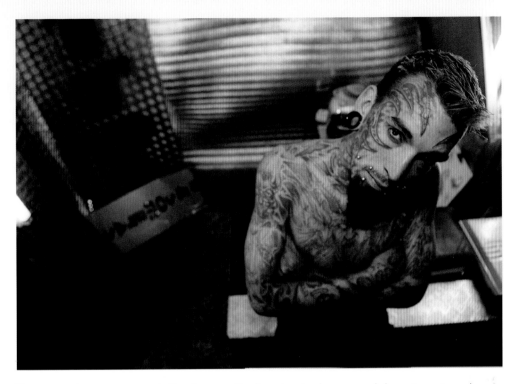

Tattoo artists can specialize in small, simple designs or elaborate artwork that covers a lot of flesh.

means they like to live life on their own terms and in a not-so-typical manner.

Tattoo artists are not just nonconformists in their appearance and beliefs, however. They are also drawn to an extraordinary career field. An ordinary job in an office would probably not be a good fit for them. At one time or another, most tattooists have felt as if tattoo artistry is what they were meant to do. For them, tattooing is more than just a job. It is a calling, where a little voice inside them tells them that this is the right—the only—job for them.

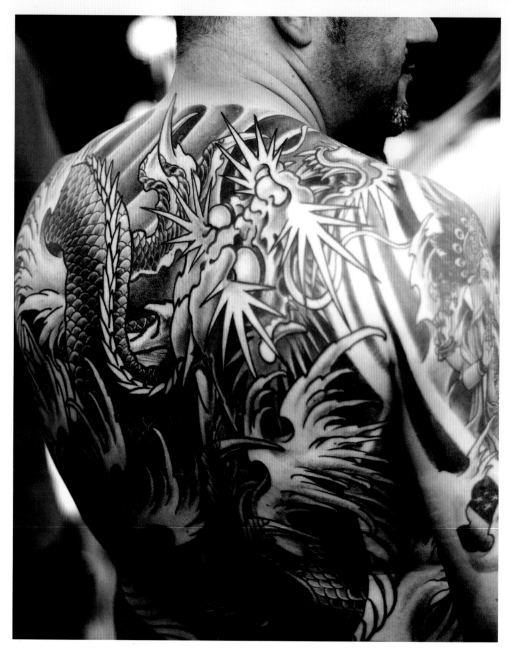

Tattoos can be simple, one-color designs or elaborate creations that can take years to complete.

What Tattoo Artists Do

Tattooing is an interesting mix of art and cosmetic surgery. It requires creativity, precision, a steady hand, and patience. Essentially, tattoo artists inject ink into a person's skin in patterns that create pictures on the client's body. Using needles, they make a series of pricks under the skin that, when grouped together, make solid lines and shades of color.

Depending on their level of experience and talent, tattoo artists may specialize in one of two kinds of tattooing. The first involves working on small designs that are quick and relatively easy to draw, known as flash. Usually, these are common designs that lots of people request, such as a skull or a butterfly.

The second type of tattoo specialty is called custom design. A tattoo artist will create a one-of-a-kind, or custom, design for one customer or group of customers. Custom designs are completely original and often complex, showing lots of detail and covering a larger portion of the body than flash tattoos. This type of design is typically done by a master tattoo artist who has been in the business a long time and has lots of experience under his or her belt.

Tattoo artists express themselves through their art, creating beautiful designs from the inner depths of their imaginations. But their main job is to help clients express themselves. Before they begin work, they consult with the customer, asking questions and, based on the person's answers and interests, suggesting designs.

Types of Tattoos

Flat—solid black with no shading, using thick lines and no detail

Traditional—simple, classic designs with thick black outlines filled with solid color

Neotraditional—like traditional, but using color layering and shading; more like cartoons

Fine line—using small needles to create thin, precise lines and lots of detail

The Traits of a Tattoo Artist

There's no one type of person who becomes a tattoo artist. A career applying body art attracts people from all cultures and economic backgrounds and both genders. Becoming a successful tattoo artist is a reachable goal regardless of your spiritual and political beliefs or ethnic background. However, certain traits are commonly found in those who choose a career in tattooing.

Artistic Talent

When some people hear the term "tattoo artist," they tend to concentrate more on the word "tattoo" than on "artist." They think that tattooing is more like tracing than true art. This concept couldn't be further from the truth. Those who tattoo

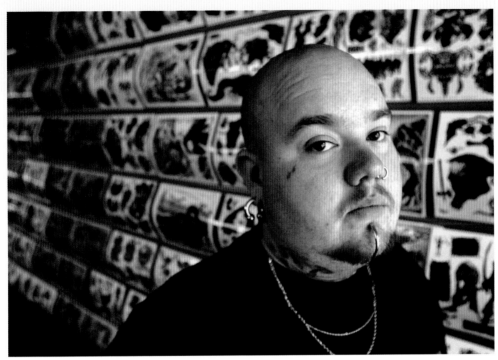

Many tattooists display their portfolios, or collections of artwork, on the walls of the shop where they work.

as a career are artists in every sense of the word. The only real difference between tattoo artists and traditional artists is the medium on which they work. Traditional artists create images on paper or canvas. For tattoo artists, skin is their canvas.

Like traditional artists, tattooists keep a collection of their work, called a portfolio. Clients look over these designs to get an idea of what kind of tattoo they would like to have drawn. A tattoo portfolio is usually displayed either on the wall of the studio where an artist works, along with general flash designs, or in a book or album that clients can look through.

The world has begun to see tattoo art in the same light as fine art. Several exhibits featuring the work of tattoo artists have been held in galleries across the United States, and in 1986, the Smithsonian's National Museum of American Art added several tattoo designs to its permanent collection.

Independence

As artists, tattooists have a unique view of the world and their place in it. They are confident in their ability to show beauty and communicate through their art. Tattooing offers them the freedom to express themselves, which they appreciate because tattoo artists are generally, by nature, independent people. Because art is very personal, they like to call the shots in their lives and their careers.

Despite all this independence, those who create tattoos also need to be able to work with people. Tattooists generally share their work space with other artists, either because they rent space in someone else's studio or they are the owner who employs or rents to others who are learning the trade. Even tattooists who choose to work on their own have to interact with clients. Talking with customers about why they want a tattoo, where they would like it placed, and what designs appeal to them is a huge part of a tattoo artist's job.

Entrepreneurship

Tattooing is not just about creating art. It is also a means to make money. So, in addition to being creative nonconformists, tattoo artists must also be smart businesspeople. Because they

Skin isn't the only canvas for tattoo artists' work. Their designs also look great on clothing and accessories.

work so independently, they have to learn how to take care of many different aspects of their business on their own. Marketing and advertising their services, as well as ordering supplies and keeping their equipment up to date and running, are some of the tasks they must perform to keep the business afloat. They should also know basic bookkeeping and accounting principles so they can keep track of payments and expenses.

Tattoo artists have to be good at budgeting their income. Tattoos are considered luxury items, meaning people don't need

them to survive. Whether people have these procedures done depends on if they have extra cash left over after they pay for necessities such as food, clothes, and housing. As a result, tattoo artists' income may vary from week to week, month to month. They need to make sure they have money set aside in case business isn't good for a while.

Code of Ethics

Despite its outlaw reputation, tattooing actually has a strict code of conduct that all artists follow. Therefore, a tattoo artist has to be ethical, meaning that he or she has to put what is right and best for the customer ahead of anything else.

For instance, most tattoo artists will not create art on a person's hands, feet, or face. They know that despite tattooing's increased popularity and acceptance, some prejudice against it remains. Hands and faces are highly visible places for tattoos, and you can't hide them for situations such as job interviews. Tattoo artists are aware that obvious body art may cause problems for people down the road, either in the workplace or elsewhere. Therefore, they won't ink hands or faces, even if it means losing a customer.

Ethical tattooists also do not work on people who are under-age. Tattooing is now legal in all fifty American states, but it is still regulated. Most states require that you have to be at least eighteen years old in order to get a tattoo. Also, tattoo artists will refuse to tattoo anyone who is under the influence of drugs or alcohol.

A Love of Tattoos

Besides having artistic talent, tattoo artists must have a love of body art. That means they should not only like drawing on other people, but should also have tattoos themselves.

On the Tao of Tattoos Web site (www.tao-of-tattoos.com), popular tattooist James "Nearly Painless" Tuck recalls his encounter with an aspiring tattooist. The nineteen-year-old man talked about how he loved tattooing and felt driven to be a skin artist. When Tuck asked how many tattoos the guy had himself, he said he didn't have any. James's response was, "Quit wasting my time."

The bottom line is that those who say they want to become tattooists will not be taken seriously by working tattoo artists if they do not practice what they preach. Before anyone even thinks about becoming a tattoo artist, he or she should first be a customer.

The History of Tattooing

Over the past few years, tattooing has become increasingly popular in the Western world, particularly the United States. A 1936 survey conducted by *Life* magazine showed that around 6 percent of all Americans had at least one tattoo. In 2003, a Harris Interactive poll indicated that number had risen to 16 percent. Just three years later, the American Academy of Dermatology, the professional organization for skin doctors, found that a full 24 percent of U.S. citizens ages eighteen to fifty admitted to having one or more tattoos.

As impressive as this growing interest may seem, the number of Americans who have tattoos is only a drop in the bucket compared to that in other countries and cultures. Tattooing has been a part of some civilizations for thousands of years.

Prehistoric Tattoos

No one knows for sure how the practice of tattooing got started. Michele Delio, author of

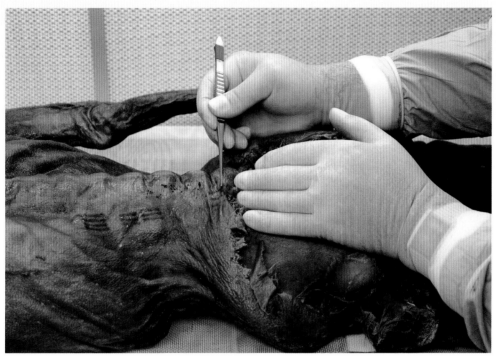

By examining the body art on mummies and frozen cave dwellers like Otzi, archaeologists can determine how old an art form tattooing is.

Tattoo: The Exotic Art of Skin Decoration, imagines that ashes from fires accidentally got into wounds and under the skin of prehistoric cavemen, who liked the way it looked and started doing it on purpose. Even though how tattooing started remains a mystery, we can guess that tattooing began at least by 3300 BCE. That is how far back anthropologists have dated an iceman they named Otzi, who was discovered in the Alps between Austria and Italy in 1991. Otzi's skin, which was well preserved because of the ice, had tattoo stripes on the right ankle and lower back, and the design of a cross behind the left knee.

Additional evidence of prehistoric tattooing has been found in the Siberian mountains, near Russia's border with China. Researchers found several tattooed mummies of a group of warriors known as the Pazyryk. One of the mummies, a Pazyryk chief discovered in the 1920s, had numerous beasts drawn on his body. Another, a woman found years later, had similar mythical creatures tattooed on her arm.

Ancient Body Art

Early tattoos have been discovered on the mummies of Egyptian kings, priests, and priestesses. Because they had alliances with other empires, the Egyptians were able to spread the practice of tattooing to nations such as Crete, Greece, Persia (now known as Iran), and Arabia, which at that time was made up of several countries in today's Middle East.

From there, researchers believe tattooing traveled to Southeast Asia and became part of Japanese culture. In ancient Japanese tombs, researchers have found small clay statues with either painted or engraved faces. They think these marks represent tattooing. There is no written evidence of tattooing in Japan until Chinese historic journals mention it around 300 CE.

An Outlawed Practice

Nearly 400 years later, Japanese rulers, imitating what they saw in Chinese culture, declared that tattooing was not civilized and outlawed it. Getting a tattoo was considered a punishment.

Women and Tattooing

In some Asian and Indonesian cultures, both men and women have applied tattoos for centuries. In fact, only women were allowed to practice tattooing within the Orang Ulu tribe of Borneo. In Western countries, though, it has been a different story.

For a long time, tattooing had been a male-dominated art form in North America, meaning the ones who did tattooing and had control over the business were men. Women have been tattooing in America since the early 1900s, but they didn't get as much work or respect as male artists. At that time, it was mostly men who got tattoos, and often they refused to have a woman work on them.

That began to change in the 1970s, as attitudes toward the role of women in society shifted and more of them began to enter the field. As tattooing has become more popular, more women are showing an interest in not only getting tattoos, but also in becoming tattoo artists themselves. Their work now receives the same attention as that of male tattooists, getting written up in tattoo magazines and being featured at art exhibits and conventions. Today, there's even an annual all-female tattoo artist convention called Marked for Life.

Starting around 700 CE, the only people in Japan who got tattoos were prisoners and outcasts.

The situation was similar in ancient Rome, where slaves were identified by their tattoos. Generally, the only non-slaves to have body art were Roman soldiers, who sported tattoos called stigmates on their hands to identify them as warriors.

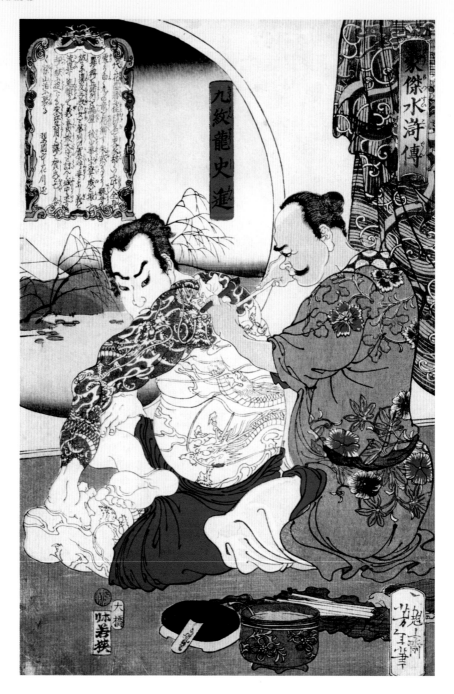

Because tattooing was prohibited in ancient China, only outlaws dared to give or get body art. In fact, Chinese criminals were known for having extensive tattoos.

The early Christian church went beyond seeing tattoos as low class or the mark of slaves. The institution considered body art to be a sin against God. This belief was based on a passage in the Bible that reads, "Do not cut your bodies for the dead or put tattoo marks on yourselves."

Consequently, Emperor Constantine, himself a newly converted Christian, outlawed the practice of tattooing across the Roman Empire. At its height, the Roman Empire covered most of Europe and a large chunk of the Middle East. So, at the time, tattooing was a punishable offense in a large part of the world. Even after the empire collapsed late in the fifth century CE, the church's influence was still strong, and the ban on body art remained. Tattooing stayed forbidden pretty much throughout the Middle Ages (400–1500).

Oddly enough, there were some Christians during this time who, against church rules, had tattoos. Knights fighting in the Crusades (1091–1295), which were a series of battles in the Middle East pitting European Christians against Muslims, frequently had small cross tattoos on their hands. The thinking was that if they died in battle, someone would see the cross and make sure the fallen knight received a Christian burial.

Tattoos Make a Comeback

Another group of Christians was responsible for reviving interest in body art. Beginning in the sixteenth century, pilgrims on a sacred journey to Jerusalem, which they considered to be a holy city, had crosses or other symbols of Christianity tattooed onto

their arms. They wanted the tattoos as a permanent souvenir of this important trip.

Commoners were not the only ones who took part in this ritual, known as pricking. Royal pilgrims such as King Edward VII of England (when he was still the Prince of Wales) and Denmark's King Frederick IX each received body art during trips to Jerusalem. In fact, King Edward received many other tattoos during his lifetime and made sure his sons were tattooed when they traveled to Japan in 1882. Soon it became fashionable for noblemen and noblewomen to sport tattoos, just like royalty.

Sailors, Explorers, and Circus Performers

In the eighteenth and nineteenth centuries, people were very interested in exploring the world around them. Sailors came back from long journeys with inked designs on their bodies, placed there by native people in faraway lands. The stories of how they got their body art, and the artists who created it, were very popular.

Tattooed sailors quickly discovered that they could make money by charging people to see their designs. Many of them joined circuses as wild men from islands in the South Pacific. By the late 1800s, every sideshow featured tattooed men and women. Circuses also frequently employed tattoo artists so they could add to and freshen up the body art of their performers. Many made a living by inking single tattoos on customers who had come to see the circus. In fact, if it weren't for these

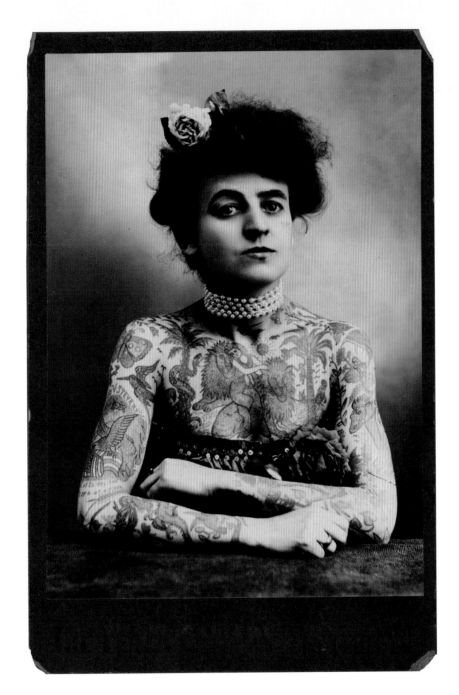

Full-body tattooing was considered an oddity in the early 1900s. However, some upper-class men and women got less flashy designs as status symbols.

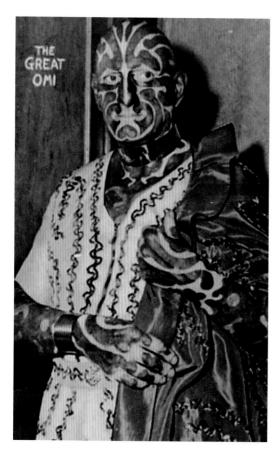
THE GREAT OMI

Having body art intimidates some people because they think only troublemakers get tattoos. The truth is tattoos are simply a unique way to express yourself.

shows, as well as small parlors that sprang up near seaside ports to serve sailors, tattoo artists would never have been able to find work.

Most tattoo artists were still working by hand until 1891. That's when New York State resident Samuel O'Reilly registered the first electric tattoo machine with the U.S. Patent Office. Patterned after an engraving machine invented by Thomas Edison, O'Reilly's machine brought tattooing into the modern age.

Modern Tattooing in America

While the practice of tattooing remained popular with sailors, soldiers, and the rich, it was slow to catch on with the general public, particularly in America. It didn't help that many tattoo parlors in the first half of the 1900s were not sanitary. Because of this, getting a tattoo meant a person risked getting blood poisoning or hepatitis. Also, body art had a reputation in America as being only for criminals and rebels. Tattooing was so unpopular, it was made illegal in most states.

In the 1970s, however, tattooing became stylish in the United States as young people used body art as a way to express themselves. Having tattoos set them apart from those in their parents' generation who thought body art was disrespectful and somewhat sleazy. This decade also was when the first custom tattoo shop opened, in San Francisco, and the first tattoo convention was held, organized by the newly formed National Tattoo Association.

When rock stars and athletes began showing off their tattoos in the 1980s and 1990s, Americans decided that body art was glamorous. It was no longer something to fear, and the number of people who got tattoos rose dramatically. Today, tattooing is extremely popular. That status shows no sign of fading soon.

Tribal Tattooing

For centuries, tattooing has been a custom for many tribes around the world, particularly in Polynesia, a group of islands in the Pacific Ocean, and Indonesia, an island chain between Australia and Asia. These include Polynesian natives of Hawaii, Tahiti, Borneo, and Samoa, and Indonesian tribes in Java, Sumatra, and Bali.

Tattooing is also a longstanding custom for tribes in Africa, such as the Makonde in Mozambique, and in the Americas. There is written evidence, dating back to at least the 1600s, of practicing tattoo artists among Native Americans in the United

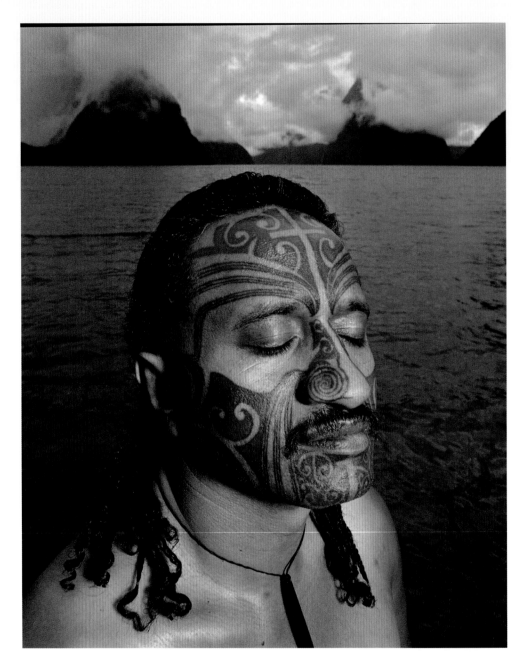

Facial tattoos are considered sacred marks in the Maori culture. Although not applied to the face, these tribal designs are popular with other cultures as well.

States and Canada, Mayans in Mexico, and Incas in Peru and other South American countries.

Two tribes that are famous for tattooing are the Maori in New Zealand and the Celts, who lived as a tribe mainly in Ireland, Scotland, and Wales in ancient times. (Because of their history of shared traditions and language, people in these countries— particularly the Irish—are still referred to as Celtic.) Many designs created by each of these tribes are popular with those getting body art to this day.

Each tribe has its own specific customs when it comes to tattooing, but there are similarities. For instance, members of native tribes tend to have many tattoos covering their bodies, including the face. Also, unlike in the Western world, tribal tattoo artists are usually older women—and they are greatly respected members of their societies.

Significance of Tattoos

Beyond being a fashion statement, tattoos serve many purposes. For instance, they can show a person's status within a society, such as how having a visible tattoo meant you were a slave in ancient Rome. They can also be a statement that you belong to a group or organization. Motorcyclists are well-known for wearing tattoos that identify them as part of certain riding clubs.

Having lots of tattoos can make a person look tough, which is another reason people have decorated their bodies. Before battle, the ancient Celts would paint themselves blue with dye made from a certain type of grass and highlight their tattoos

by fighting without shirts or completely naked, in order to threaten their opponents.

Just as Christian soldiers during the Crusades had crosses on their hands, members of other religions place symbols of their faith on their skin. Members of the Ramnaamis sect of Hinduism tattoo the name "Ram" over every inch of their bodies, even inside their mouths.

Body art also can be a preparation for the afterlife. The Maoris believe spirits will see the tattoos on their face and help them into the next world, while the Dayaks of Borneo think the marks on their hands will light the darkness after they die so that their souls can find the River of the Dead. Native American tribes such as the Lakota and the Alaskan Inuits also use tattoos to help them prepare for leaving this world.

One of the biggest reasons people get tattoos is to permanently record special moments of their life. Tahitian girls have gotten tattoos when they reached sexual maturity. To honor someone who had died, Hawaiians used to tattoo black dots on their tongues. These days, people may have the name or image of someone they love, or simply a design that has significance to them, tattooed on their skin.

How Tattoos Are Created

The principles of tattooing are pretty basic. The tattoo artist creates a design on a person's skin, then adds some kind of pigment, or color, to make the image permanent. This is accomplished by making a cut or a prick through the top, outer layer of the skin, called the epidermis. The pigment is placed under the epidermis but on top of the next layer of skin, called the dermis. There is a third, deeper layer of skin, the subcutaneous layer, but that isn't involved in tattooing. Tattoo needles go into the skin only about 1/16th of an inch (1.58 millimeters).

These days, tattoo artists use special electric instruments, inks, and sanitary procedures to complete their work. Before that, however, most tattooing was done by hand, using various crude tools and pigments.

Old Methods

In ancient Rome, the skin was pricked with needles to form a design, which was then rubbed with an ink made of crushed pine

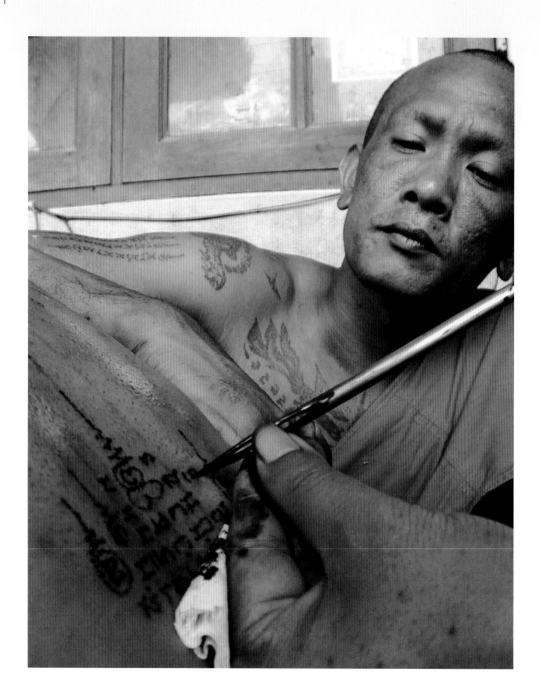

Some tattoo artists still use traditional tools to ply their craft. Old methods of tattooing relied on bundles of needles and scratches made by force.

bark, powdered bronze, vinegar, water, and leek (onion) juice. Egyptians mixed animal fat and soot for their color. Certain Eskimo tribes dipped a thread soaked in their own urine into a pile of lamp ashes, then used a needle to pull the thread under the skin to create their designs.

Japanese tattoo artists worked with large steel needles arranged in rows and tied to a bamboo handle, called a tebori. The needles were dipped in ink and forced into the skin using only the artist's strength. A few master artists in Japan still use this technique.

Meanwhile, Maori tribes adapted their wood-carving technique to create body art, using the same type of bone instrument to cut designs into both wood and skin. These days, Maoris are more likely to use tools made of metal instead of bone, but the procedure remains pretty much the same.

Some tribes, such as the Samoans, tattooed large sections of their skin with very complicated designs that took hours, even days, to complete. Tapping the chisel took a lot of time and was very painful for the person being tattooed. Because of this, tribal tattoo artists frequently needed the help of at least one assistant, to help hold the skin taut and restrain the person getting the tattoo.

The Tattooing Machine

Gone are the days of tapping bones into people's flesh to create a tattoo. Since the invention of the first electric tattoo machine in 1891, applying body art has become much easier and faster.

The tattooing machine is based on an automatic engraver invented by Thomas Edison. With Edison's machine, electricity delivered by using a foot pedal caused a rotor to move quickly in a circle. Each time the rotor spun around, it repeatedly pushed down and pulled back up a bar that had a needle attached. This action made the needle dart in and out.

American inventor Samuel O'Reilly patented and added an ink reservoir, or holding place, to Edison's machine, and tubes running from the reservoir allowed ink to flow to the needle. The machine worked like a handheld sewing machine, only instead of thread onto fabric, ink was inserted into skin.

Today's tattooing machines work pretty much the same way as the original equipment, except instead of a rotor, the newer machines use magnets to move the needle, or group of needles, up and down. Current machines can puncture the skin up to 3,000 times a minute.

Modern Needles

Tattoo artists apply precise amounts of ink in very specific places to create clean designs without blobs of color or other errors. Needles are the perfect tool for this kind of work. They pierce the skin yet don't leave big wounds, and are small enough so that the artist can control his or her drawing.

The needles used in tattoo machines, called sharps, are typically made of stainless steel. Several sharps are attached to a machine's needle bar at one time. How many sharps are used and how they are arranged on the needle bar determine

the kind of line or amount of color that will show up on the skin. For drawing lines, known as lining a tattoo, a small number of sharps are placed in a circle. The smaller the circle and closer together the sharps are, the finer the line. Flats, or sharps that are arranged in a straight row, work well for shading, which gives a tattoo dimension. Filling in large areas with color is best done using magnums, which are two or more rows stacked on top of each other.

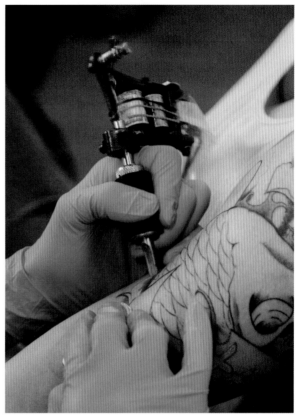

The electric tattoo machine modernized the way body art was created. Tattooists could create intricate designs in much less time with this equipment.

The Chemistry of Color

The ink used by tattoo artists is a combination of pigment and what's known as a carrier. Pigments are substances, usually metal or plastic particles, that reflect light in a certain way to create various colors. Tattoo pigment comes in a powder form. Carriers are fluids that mix with the pigment powder but do not overpower it, which would make the ink too runny. The pigment should be suspended in the carrier, which means the chemicals in both the pigment and the carrier are spread throughout the

mixture equally. Among the most common carriers found in tattoo ink are alcohol, purified water, witch hazel, and glycerin.

Ready-to-use inks are sold by commercial tattoo supply shops, but some tattoo artists choose to mix their own ink. This is tricky business. Anyone mixing his or her own ink has to make sure to use quality ingredients and must see to it that the entire process is sterile, or germ-free. If germs get into the mixed ink, they can cause major health problems when injected under a person's skin. For instance, pigments should never be sterilized using heat because that can change the chemicals in the powder, making them toxic, or poisonous.

Other Equipment

Another piece of equipment used by tattoo artists is a tattoo chair, which is kind of like a cross between a recliner and a dentist's chair. Because these chairs are adjustable, tattoo artists don't have to stretch or strain as much to get in a good position to draw.

These days, tattoo artists may also invest in a thermal-fax. This machine scans a tattoo artist's original freehand designs onto special heat-sensitive paper. The design is not so much copied as developed like film, where drawn lines are "burned" onto the special paper. The result is a copy of the design that will transfer onto the person's skin like a stencil.

Many other tattooing tools revolve around sanitation, which involves making sure the process is extra clean and without the

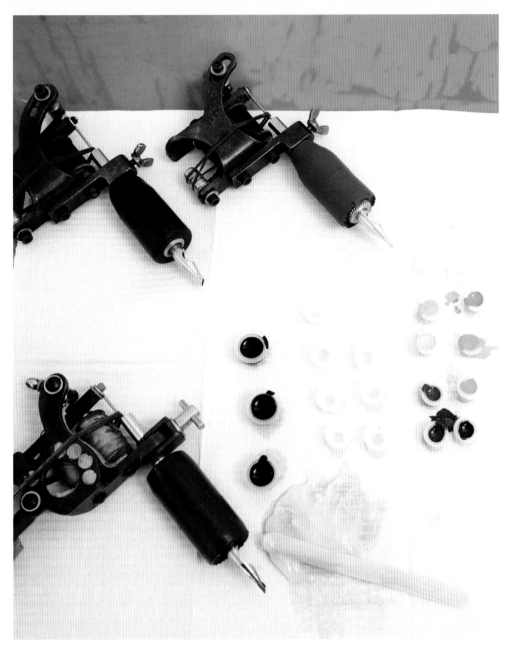

The tools a body artist uses include a tattoo machine with multiple needle bars and reservoirs, disposable cups of ink, and latex gloves.

chance of disease. The most important of these is an autoclave, a machine that uses steam pressure and high temperatures to sterilize instruments. An autoclave is used to clean reusable items that a tattoo artist might use, such as the stainless-steel tattoo machine tubes that deliver ink (although some artists use disposable plastic tubes), forceps to hold skin tight, and any other equipment that might come in contact with the customer. Needles, which are used only one time, are sterilized at the company that manufactures them. Tattoo artists still use distilled water to rinse needles during use, when they want to make sure the sharps don't get too coated with color, or when they want to change color.

Other items used to prevent disease include rubbing alcohol, to disinfect the client's skin beforehand, and distilled water, which is water that has been processed so that it's extra clean. Tattoo artists use distilled water to make steam in the autoclave, and may wash their hands with it. Tattooists must wash their hands frequently, especially between working on clients, even though while giving a tattoo they wear latex gloves—another necessary supply when applying body art.

Tattoo artists should have disposable razors and stick deodorant on hand as well. The razors are because skin just about anywhere on the body has at least tiny hairs on it, and the area must be clean and hairless before it can be tattooed. The deodorant is used to attach design stencils to the body; deodorant helps keep the paper in place and makes the stencil transfer darker.

Finally, first-aid supplies are necessary for what is known as aftercare. Because the skin is punctured, a tattoo is essentially a wound, and it needs to be cleaned and protected. Some kind of ointment and adhesive bandages are a must in any tattoo studio.

Creating Body Art

A client shows up and wants a tattoo. (In many custom shops, the customer makes an appointment ahead of time.) The tattoo artist lets the client look through his or her portfolio, then discusses what kind of design the client has in mind. Once the design is decided upon, or possibly as soon as the client walks in the door and requests a tattoo, the artist must ask for identification that has proof of age on it. Legally, no one under the age of eighteen can receive a tattoo in the United States.

Next, the artist has the client sit in the tattoo chair so that the area to be tattooed can be shaved and cleaned with alcohol. He or she also makes a stencil of the design that the client has chosen. The stencil is a copy of the design that can be transferred onto the client, creating a guide or outline from which the tattoo artist works. The stencil is stuck temporarily to the skin using stick deodorant, which the tattooist first applies to a tissue that he or she wipes on the skin. This helps to prevent contamination because the stick of deodorant does not directly touch the skin of several clients.

After the stencil is applied, the artist gets all of the instruments in order. He or she places the ink needed in tiny

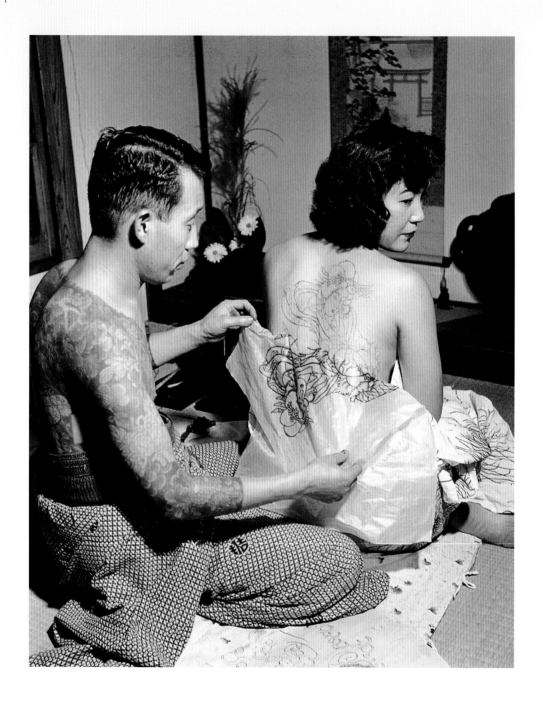

Using special removable paper, tattoo artists stencil their designs onto clients' skin first, as a guide. Then they fill in the outline with ink.

disposable cups and has a cup of distilled water ready for rinsing off needles and other tools. At this time the artist also gets the tattooing machine ready, putting it together with a clean reservoir and fresh tubes in a few easy steps. Sterilized needles are taken out of their bags and attached to the machine's needle bar.

Also, a bit of petroleum jelly will be squeezed out of its tube so the artist can place a layer of it over the stencil. This keeps the stencil from getting smudged and lets the needle glide more easily and comfortably over the client's skin.

Once all the preparation has been done, the artist can start to tattoo. First, he or she does line work, which is retracing the outline of the stencil. The artist works carefully on this, making sure not to smudge the stencil. After line work comes color, if there is any, and shading. While the tattoo is being applied, blood may appear on the skin. This is normal, and the tattoo artist will wipe away whatever spots of blood there are.

Finally, the tattoo is finished, but the tattoo artist's work is not. First, he or she cleans the area that has been tattooed, making sure to get rid of all traces of any petroleum jelly used. Over time, the jelly can react chemically with the ink and make the tattoo fade. Second, the tattoo will be completely covered with an adhesive bandage. This is done for the same reason you cover a cut with a Band-Aid. The bandage gives the pricks and small cuts in the flesh a chance to heal and keeps out bacteria that can cause infection.

Last, the tattoo artist will give the client detailed instructions on how to take care of his or her tattoo, verbally and in writing.

These include when to take off the bandage, how to wash and dry the tattooed area, and specific activities and products to use or avoid. Perhaps the most important instruction the tattoo artist can give is to see a doctor if the tattooed area shows any sign of infection, which will be covered in the next chapter. Tattooists are excellent artists, but they are not doctors. A medical professional should be contacted for all concerns about the client's health.

Working as a Tattoo Artist

Being a tattoo artist is not a typical career, but that's one of the things that makes this type of work so appealing to some people. For them, tattooing is also more than a job. Body artists are part of a culture that has its own special traditions and beliefs, a community of people who think alike, have similar interests, and enjoy each other's company. More than a job, being a tattoo artist involves living a very unique lifestyle.

So, how does someone become a tattooist? Obviously, he or she has to have a talent for and interest in body art. But there's more to it than that. Just as with any other career, tattooists have to learn and master certain skills. These include knowing how to sterilize equipment or fix a jammed tattoo machine. Tattoo artists also have to keep current on any certification or licensing that may be required, as well as the many safety procedures that their line of work requires.

Education and Training

When it comes to education, tattoo artists have many different learning backgrounds. Some have taken art classes in high school and may even have gone on to study drawing or painting (in other words, fine art) in college or junior college. Others show an interest or talent in graphic design, using a computer instead of pencil, paints, and paper to create images and express themselves artistically.

Many, however, take a somewhat looser approach. They come to tattooing without much formal education. Their training starts by drawing pictures that their parents have proudly displayed on the refrigerator and moves on to doodles and pictures that they sketch in school notebooks or on any available piece of paper.

In America, tattoo artists are overseen by the individual states in which they operate. Each state determines what sort and level of education is required to get a license to create body art. Some states require tattooists to obtain either a high school diploma or their General Educational Development (GED) degree. To be licensed, tattoo artists also have to pass a test, which can be written or practical, which means being judged and graded by how well the artists tattoo someone. For safety reasons, most states also require that tattooists be certified in CPR and first-aid procedures.

When it comes to professional career training, however, all the states agree. Each requires completion of an apprenticeship to become a licensed tattoo artist.

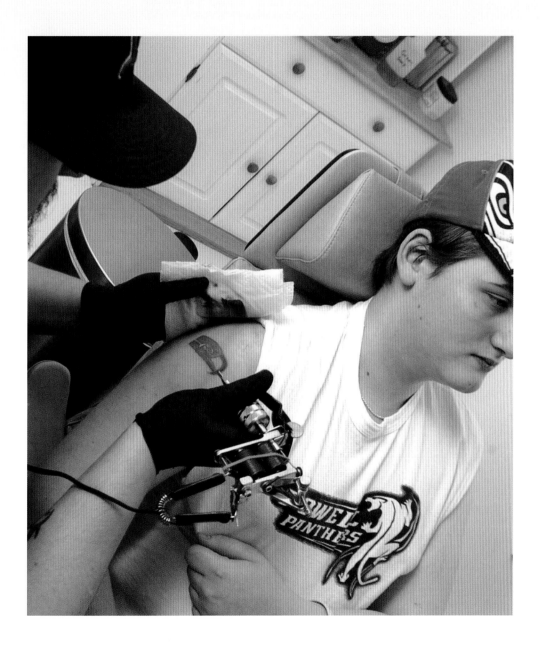

Practice makes perfect. Tattoo artists in the United States must train and practice their skills before becoming licensed.

A Word About Scratchers

Some people think all you need to be a tattoo artist is a little drawing talent and a tattoo machine. They order do-it-yourself tattoo kits from shady ads in the backs of magazines—or worse, try to build their own tattoo machines—and practice on a few willing victims. Their sterilization methods leave a lot to be desired. They haven't apprenticed or even studied body art, so they really don't know what they are doing. These people are known in the world of tattooing as scratchers.

The growing popularity of tattooing has brought a lot of scratchers into the business. They think it's an easy way to make a few bucks. Unfortunately, they make trouble as well. Because they are self-taught, scratchers are more likely to use too much pressure on the skin, which causes permanent scarring. Scratchers put their customers' health at risk by using unclean or unprofessional equipment. They are also hazardous to legitimate tattoo artists because scratching ruins the reputations of true professionals and gives tattooing a bad image.

Apprenticeship

Tattoo artists learn, and get to practice, their craft through what is known as an apprenticeship. One of the oldest forms of training in the Western world, apprenticeship involves working side-by-side with an experienced worker who acts as a coach. This person, usually a master tattooist or the owner of a tattoo studio, is known as a mentor.

Tattooing apprenticeships can last a couple of years. People move through an apprenticeship one level at a time, proving they can perform at one level before moving on to the next. As an apprentice, tattooing hopefuls start out learning about the different equipment and basically making themselves useful around the studio, maybe sweeping up or answering the phones.

Next, they get to practice on nonhuman models, such as an orange or grapefruit, or maybe a hunk of leather. Finally, they work on flesh, starting with friends of theirs who are willing to be test subjects and, eventually, the shop's customers. At first they concentrate on simple flash designs, then work their way up to the more complex stuff.

Most tattooing apprentices do not get paid for their work. In fact, many studios charge to take someone on as an apprentice, and it isn't cheap. Mentors can receive several thousand dollars to train someone. Some let apprentices train for free, but they have to promise to work in the studio for a certain amount of time after the apprenticeship is over.

Health and Safety Concerns

All tattoo artists, from beginners to those who have been on the job for years, need to make safety a top priority in their work. The most obvious health threat that body artists are on guard against comes from one of their most important tools— tattoo needles.

Cuts or openings in the skin make it easier for germs to get into a person's body. Consequently, using needles increases the risk of getting an infection. Bacteria and viruses can be found in pigments as they are being mixed, or on instruments that haven't been sterilized properly. What's more, the threat isn't only to customers. Working with sharps, tattoo artists risk cutting and sticking themselves each time they come in close contact with the needles.

Tattooists are especially aware of spreading blood-borne illnesses, which are diseases that are carried throughout the body, and can be passed from person to person, via the bloodstream. Like doctors and nurses, then, tattoo artists must be experts in how to properly get rid of hazardous materials, meaning items that have come in contact with a person's bodily fluids.

Blood is the primary cause for concern when it comes to tattooing. The Environmental Protection Agency (EPA) and the Occupational Safety and Health Administration (OSHA), which are agencies of the federal government, each have strict guidelines regarding the disposal of needles. The Alliance of Professional Tattooists, a nonprofit organization that oversees tattooing health and safety concerns, offers certification courses on blood-borne pathogens (germs), safety, and disease prevention.

The American Academy of Dermatology, a group of doctors specializing in skin-related conditions and diseases, has noted that nonsterile tattooing and the improper disposal of needles can lead to all sorts of illnesses, such as syphilis

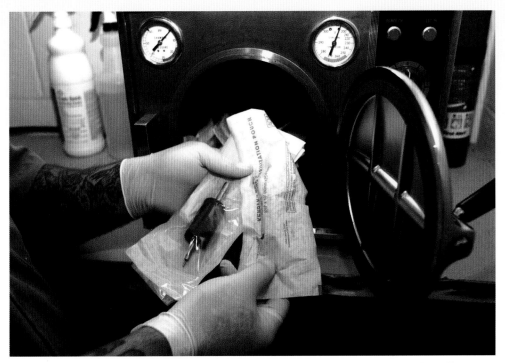

An autoclave is the best defense a tattooist has against transmitting disease and infection. Every tattoo artist should know how to use these machines, which sterilize needles and other equipment.

and tuberculosis. Far and away, though, the biggest blood-borne health threat faced by every tattoo artist is hepatitis, followed closely by HIV/AIDS.

Hepatitis

Hepatitis is a virus that damages your liver, an important organ that stops bleeding and cleans poison and other harmful substances from your body. There are several strains, or types, of hepatitis. The ones most associated with tattooing are hepatitis B and C.

People who have hepatitis feel very worn out and sick to the stomach. They also have a fever and may develop stomach pain and diarrhea. Eventually, the disease can shut down a person's liver and even kill him or her. Doctors can help control hepatitis, but there is no cure for this disease. Once you get it, you have it for life.

One of the chief ways to get hepatitis is through a needle that has been used on someone already infected with the virus. Usually, this involves needles used to inject legal and illegal drugs. However, any type of needle can be the culprit. In 1961, infected tattoo needles were blamed for a major outbreak of hepatitis in New York City. The result was that tattooing was banned in New York State until 1997, when it was made legal.

In 2001, a scientist named Robert Haley conducted a study to see if tattoo needles were responsible for people developing hepatitis C. The results, published in the journal *Medicine*, showed that people who have been tattooed are nine times more likely to get the disease than people with no body art.

Haley's former employer, the U.S. Centers for Disease Control and Prevention (CDC), points out that the study wasn't very big, which makes the results questionable, and that there's no concrete evidence linking tattoos and hepatitis. However, CDC scientists admit there have been reported cases of hepatitis caused by tattoo needles, so tattoo artists and clients should be very careful.

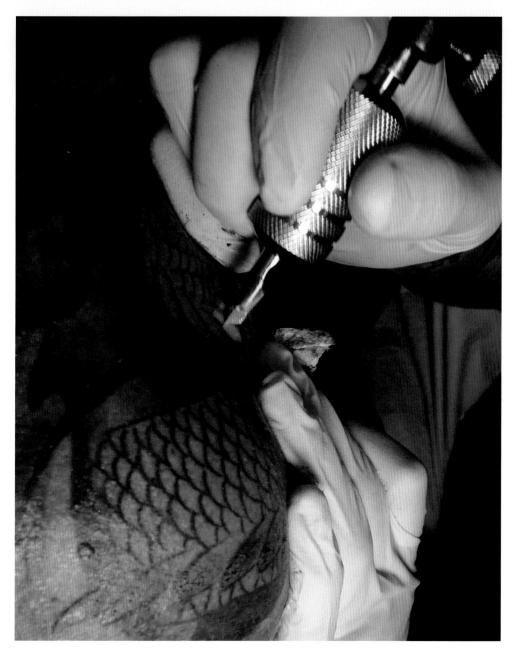

Because they are making cuts in a person's skin, tattoo artists need to wear gloves in order to avoid contracting blood-borne diseases.

HIV/AIDS

The human immunodeficiency virus, or HIV, affects the immune system, which is responsible for fighting off disease. Basically, the virus stops certain cells from doing their job, which gives all types of infections a chance to invade the body. The worst of these is acquired immunodeficiency syndrome, or AIDS. HIV infection leads to AIDS, which is when the body's immune system has been completely destroyed and deadly diseases have started taking over the body. There is no cure for HIV or AIDS.

HIV can enter the body through any break in the skin, passed on through the blood or other bodily fluids of an infected person. That means if there is even a trace of infected blood on a needle or any other tattooing instrument, HIV can be passed on to anyone who gets cut or stuck by that needle.

To reduce the risk of getting HIV, AIDS, hepatitis, or other blood-borne diseases during tattooing, needles and other sharp objects—such as razors for shaving the area to be tattooed— should be used only once and on only one client. Also, the area being tattooed should be kept sterile, which means cleaning the skin before, during, and after the tattoo is applied.

A Challenging Career

Despite long apprenticeships and the always-present risk of injury and disease, hundreds of people decide to become tattoo artists every year. The Alliance of Professional Tattooists esti-

mates that somewhere around 10,000 professional tattooists are at work in the United States alone.

The APT also states that many new tattoo artists leave the field after only five years. Some of this loss can be explained by normal workplace attrition, which is when employees leave a job for personal reasons or simply because they want to try something new. Yet there's also the possibility that a career as a tattoo artist is tougher than they thought.

Tattooing is full-time work. On average, tattoo artists work five or six days a week, usually starting late in the morning or early afternoon and staying on the job for at least eight hours, sometimes more. Working evenings and weekends is typical because that's when clients are most likely to get tattoos—when they themselves are not working. Artists can create several tattoos a day, depending on how many customers they have and how large and involved each design is.

Even when they're not tattooing someone, there's plenty to do. Tattoo artists don't just hang around in between appointments. They are busy cleaning their equipment and the studio, or creating designs to add to their portfolios.

The job is physically challenging as well. Tattoo artists stand quite a bit in order to work on clients, and even when they sit, their hands and arms are in constant use. Their muscles frequently get cramped and achy.

Salaries for tattooists vary according to where they live, as well as their talent and experience. Most charge by the hour, anywhere from around $40 for those who are just starting out to hundreds of dollars for masters of the art. Tattooists working

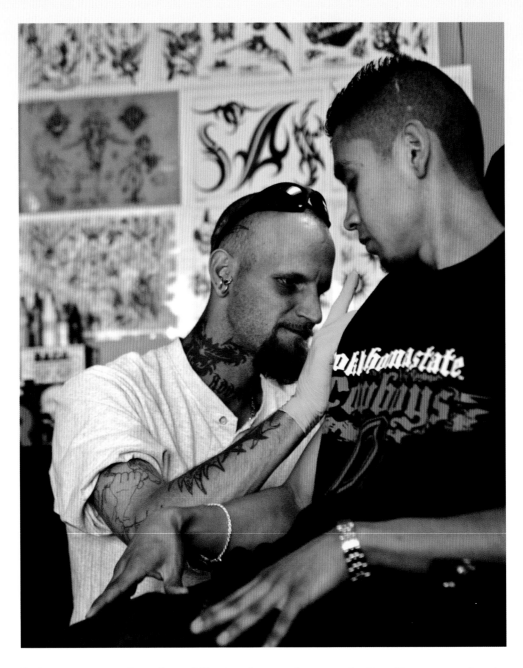

Being a tattoo artist takes skill, stamina, and concentration. You may not get rich in this career, but there are other rewards besides money.

in someone else's studio give the owner a large percentage of their income, paying rent for their space in the studio. Generally, tattoo artists receive little or no medical or retirement benefits, and there's no such thing as a paid holiday.

Still, as a general rule, you'd have a hard time finding any tattoo artist who would say that he or she would rather be doing something else. The bottom line is that being a tattoo artist is not a typical career, but it can be a truly rewarding one.

GLOSSARY

attrition A reduction in the number of people engaged in an activity or job.

autoclave A machine used to sterilize tools.

blood-borne illness A disease carried throughout the body via the bloodstream.

carrier A fluid that mixes with pigment powder to make tattoo ink.

entrepreneurship Starting and running one's own business.

flash Simple designs that are created by companies and sold to tattoo shops everywhere.

forceps Medical instruments used for grabbing at objects.

nonconformist Someone who lives life on his or her own terms, usually going against what is considered normal.

pathogen A germ that causes disease.

Pazyryk A prehistoric tribe that lived in the mountains of Siberia.

pigment Metal or plastic particles that reflect light to create various colors.

portfolio A collection of artwork.

scratcher A self-taught tattoo artist who does poor work.

sharps Another name for tattoo needles.

sterile To be extra clean and totally germ-free.

stigmates Tattoos that identified ancient Roman soldiers.

tapping The process of applying tattoos that was used before the invention of the electric tattoo machine.

tebori Ancient Japanese tattooing instrument made up of large steel needles arranged in rows and tied to a bamboo handle.

FOR MORE INFORMATION

Alliance of Professional Tattooists

9210 S. Highway 17-92

Maitland, FL 32751

(407) 831-5549

Web site: http://www.safe-tattoos.com

The Alliance of Professional Tattooists is a nonprofit organization that educates the public on health and safety issues in the tattoo industry.

Canadian Association of Professional Tattooists

10359 82 Avenue, Northwest Floor

Edmonton, AB T6E 1Z9

Canada

(780) 413-7233

The Canadian Association of Professional Tattooists is an organization that was created to fight for health guidelines to regulate the Canadian tattooing industry.

Empire State Tattoo Club of America

P.O. Box 1374

Mt. Vernon, NY 10050

Affiliated with the Professional Tattoo Artists Guild, the Empire State Tattoo Club of America is an international organization of tattoo artists and individuals with tattoos that sponsors competitions and works to increase public awareness of tattoo art.

National Tattoo Association (NTA)

485 Business Park Lane

Allentown, PA 18109

(215) 433-7261

Web site: http://www.nationaltattooassociation.com

The NTA promotes tattooing as a contemporary art form and seeks to upgrade the standards and practices of tattooing, particularly those pertaining to hygienic practices.

Tattoo Club of America, Inc. (TCA)

c/o Spider Webb's Studio, Captains Cove Seaport

1 Bastwick Avenue

Bridgeport, CT 06605

(203) 335-3992

The TCA gives annual awards, sponsors a speakers' bureau, and maintains a hall of fame, library, and museum in an effort to promote the art of tattooing.

Web Sites

Due to the changing nature of Internet links, Rosen Publishing has developed an online list of Web sites related to the subject of this book. This site is updated regularly. Please use this link to access the list:

http://www.rosenlinks.com/ttt/taar

For Further Reading

Baxter, Bob. *Tattoo Road Trip: The Pacific Northwest.* Atglen, PA: Schiffer Publishing, 2002.

Currie-McGhee, Leanne K. *Tattoos and Body Piercing.* Farmington Hills, MI: Lucent Books, 2005.

DeMello, Margo. *Encyclopedia of Body Adornment.* Westport, CT: Greenwood Press, 2007.

Gay, Kathlyn. *Body Marks: Tattooing, Piercing, and Scarification.* Minneapolis, MN: Milbrook Press, 2001.

Mitchel, Doug. *Advanced Tattoo Art* (How-To Secrets from the Masters). Stillwater, MN: Wolfgang Publications, Inc., 2006.

Reybold, Laura. *Everything You Need to Know About the Dangers of Tattooing and Body Piercing.* New York, NY: Rosen Publishing Group, 2001.

BIBLIOGRAPHY

Alonso, Eduardo. "No Pain, No Gain." *Free! Magazine.* Retrieved October 8, 2007 (http://www.freemagazine.fi/content/view/218/147).

Baxter, Bob. "Terry Tweed Interview." *Skin & Ink.* January 2002. Retrieved September 16, 2007 (http://www.deluxetattooparlor.com/Pages/baxter.html).

Centers for Disease Control and Prevention. "Can I Get HIV from Getting a Tattoo or Through Body Piercing?" November 27, 2006. Retrieved October 7, 2007 (http://www.cdc.gov/hiv/resources/qa/qa27.htm).

Centers for Disease Control and Prevention. "CDC's Position on Tattooing and HCV Infection." December 8, 2006. Retrieved October 7, 2007 (http://www.cdc.gov/ncidod/diseases/hepatitis/c/tattoo.htm).

Delio, Michelle. *Tattoo: The Exotic Art of Skin Decoration.* New York, NY: St. Martin's Press, 1993.

eHow Business. "How to Open a Tattoo Studio." Retrieved September 16, 2007 (http://www.ehow.com/how_2066232_open-tattoo-studio.html).

eHow Careers and Work. "How to Become a Licensed Tattoo Artist." Retrieved September 16, 2007 (http://www.ehow.com/how_2078805_become-licensed-tattoo-artist.html).

Feruson, Henry, and Lynn Procter. *The Art of the Tattoo.* Philadelphia, PA: Courage Books (Running Press Book Publishers), 1998.

Gilbert, Stephen G. *Tattoo History: A Source Book.* Brooklyn, NY: PowerHouse Books, 2001.

Helmenstein, Anne Marie. "Tattoo Ink Chemistry." About.com. Retrieved October 5, 2007 (http://chemistry.about.com/library/weekly/aa121602a.htm).

Hudson, Karen. "Tattoos/Body Piercings." About.com. Retrieved October 1, 2007 (http://tattoo.about.com/cs/beginners/a/aa052903a.htm).

Ink Sling Tattoo Supply. "Tattoo Needles." Retrieved October 5, 2007 (http://www.inksling.com/tattoo_needles.htm).

Krutak, Lars. "History of Tattooing in the Arctic." Tattoos.com. Retrieved September 20, 2007 (http://bodydragon.com/metinler/tattoo_10_tattoos_of_the_early_hunters.html).

Love to Know Tattoos. March 9, 2007. Retrieved October 5, 2007 (http://tattoos.lovetoknow.com/Tattoo_Supplies).

Miller, Jean-Chris. *The Body Art Book: A Complete, Illustrated Guide to Tattoos, Piercings, and Other Body Modifications.* New York, NY: The Berkley Publishing Group, 2004.

Monster.com. "Career Advice—Tattoo Designer." Retrieved September 23, 2007 (http://jobprofiles.monster.com/Content/job_content/JC_Entertainment/JSC_GraphicVisualArts/JOB_TattooDesigner/jobzilla_html?jobprofiles=1).

National Institutes of Health. National Digestive Disease Information Clearinghouse. "What I Need to Know About Hepatitis C." Retrieved October 7, 2007 (http://digestive.niddk.nih.gov/ddiseases/pubs/hepc_ez).

New York. "Tattoo Timeline." Retrieved October 7, 2007 (http://nymag.com/guides/everything/tattoos/37978).

PBS. "Skin Stories: The Art and Culture of Polynesian Tattoo." 2003. Retrieved September 8, 2007 (http://www.pbs.org/skinstories/history/index.html).

Simmons, Lamaretta. "The Organic Canvas." *F Newsmagazine*. The School of the Art Institute of Chicago. April 2002. Retrieved September 15, 2007 (http://www.artic.edu/webspaces/fnews/2002-april/aprilfeatures1.html).

Tao of Tattoos. "Tattoo Artist 'Nearly Painless' James, Epic Tattoo, Woodstock, GA." Retrieved September 17, 2007 (http://www.tao-of-tattoos.com/tattoo-artist-james-tuck.html).

ScienceDaily. "Tattooing a Major Route of Hepatitis C." University of Texas Southwestern Medical Center at Dallas. Retrieved October 7, 2007 (http://www.sciencedaily.com/releases/2001/04/010405081407.htm).

VanishingTattoo.com. "Tattoo Facts and Statistics." Retrieved September 15, 2007 (http://www.vanishingtattoo.com/tattoo_facts.htm).

INDEX

About the Author

Jeanne Nagle is a writer and editor based in upstate New York. Her personal experience with body adornment is limited to medical and temporary tattoos, as well as pierced ears. Through comprehensive research, however, she has gained a great deal of knowledge about the tattooing community, which she finds absolutely fascinating.

Photo Credits

Cover © AFP/Getty Images; p. 5 © Steve Granitz/Getty Images; p. 7 © Andres Stapff/Reuters/Corbis; p. 8 © Dave Etheridge-Barnes/Getty Images; p. 11 © Jesse Neider/ Syracuse Newspapers/The Image Works; p. 13 © Mark Davis/Getty Images; p. 17 photo detail by South Tyrol Museum of Archaeology, Bolzano, Italy/Wolfgang Neeb/The Bridgeman Art Library; p. 20 © Asian Art & Archaeology, Inc./ Corbis; p. 23 Library of Congress Prints and Photographs Division; p. 24 © Tattoo Archive; p. 26 © Chris Rainier/Getty Images; p. 30 © Reuters/Corbis; pp. 33, 35 Shutterstock.com; p. 38 © Bettmann/Corbis; pp. 43, 47, 52 © AP Images; p. 49 Wikimedia Commons.

Designer: Les Kanturek; **Editor:** Nicholas Croce
Photo Researcher: Cindy Reiman